THE MISSING PIECES

Paul Hindemith ser

Milena Jesenska nrich von Kleist

 Robert

Creeley

 Annemarie

Schwarzenbach

 Miguel de Cervantes Jean Giono

 Osip Mandelstam Pierre

Guyotat Jerome David Salinger

 James

Joyce

Published as *Les Unités perdues* © Manuella Editions, 2011.
First published in 2004 by Éditions Virgile.
This translation © 2014 by Semiotext(e).

Published by Semiotext(e)
PO BOX 629, South Pasadena, CA 91031
www.semiotexte.com

Number 21 of a series of 22 publications published on the occasion of the
2014 Whitney Biennial.

Special thanks to Erik Morse, Noura Wedell and Marc Lowenthal.

Design: Hedi El Kholti

ISBN: 978-1-58435-159-7
Distributed by The MIT Press, Cambridge, Mass. and London, England
Printed in the United States of America

HENRI LEFEBVRE • THE MISSING PIECES

TRANSLATED BY DAVID L. SWEET

semiotext(e)

*To Liliane Giraudon
and Jean-Jacques Viton*

Murder, The Hope of Women, a twenty-five minute opera composed in 1919 by Paul Hindemith • The novel *Theodor* by Robert Walser • The letters of Milena Jesenska to Franz Kafka • Heinrich von Kleist burns the manuscript of *Robert Guiscard, The Duke of the Normans* and attempts to enlist in Napoleon's army when the poet Wieland informs him of his admiration for this text • Missing, the poems of Robert Creeley, which littered the hardwood floor of Brautigan's house in Bolinas, on drunken nights; Brautigan would gather them in the morning and put them in a bowl on the piano, "for posterity," he'd say • The *Journal* of Annemarie Schwarzenbach, destroyed by her mother • *La*

Confusa, a comedy by Miguel de Cervantes • In 1933 and from 1937 to 1938, Jean Giono shot fragments of poetic films without characters; none of the works exist any longer • The contents of a telephone conversation between Stalin and Pasternak after the arrest of Osip Mandelstam • Pierre Guyotat's head of hair • Jerome David Salinger since 1959 • The "line" of Apelles • Because his editors refused to publish *Stephen Hero*, James Joyce threw the manuscript into the fire in 1905; at the cost of some burns, his companion, Nora, saved a fifth of the text • The manuscript of a drama by Georg Büchner on Aretino; *Woyzeck* was never completed • *Bezhin Meadow*, a film by Sergei Eisenstein • A *féerie* by Claude Debussy and René Peter that was to be made up of fourteen tableaux but which got no further than the title: *The Thousand and One Nights of Anywhere and Elsewhere*; then, a dramatic satire entitled *B.I.A. (The Brothers in Art)* that got no further than the first scene of the second tableau • The four great altarpieces of Matthias Grünewald for the cathedral of

Mainz • The end of *The Prodigal Son*, an opéra bouffe by Emmanuel Chabrier • The first novel of Max Frisch, *Stahl*, written in 1927 • *The Winter Journey* by Louis-René des Forêts, was burned by the author except for two chapters • The great university library at Louvain, destroyed in a fire in 1914, and the library of Sarajevo, bombarded in the winter of 1992–1993 • *Le Fils des étoiles, Rhapsodie romane, Oedipus und die Sphinx, Prélude à la fin d'un jour, Mehr Licht*, works by Edgar Varèse lost in the fire of a Berlin warehouse during the Spartakist uprising; *The Cycles of the North*, a work sent to Bartók in 1914, lost in the mail; *Bourgogne*, a score destroyed by Varèse shortly before his death • The movie theater L'Espace Saint-Michel burns down on October 12, 1988, after screening *The Last Temptation of Christ* • Between 490 and 455 BCE, Empedocles composes two poems of five hundred thousand verses, *On Nature* and *Purifications*; only a few fragments have come down to us, a bit less than five thousand verses • The two canvases of the Danish painter, Vilhelm

Hammershøi, purchased, in 1897, by Diaghilev • In November 1994, a month before his death, Guy Debord burns the third volume of his *Panegyric* • From 1856 to 1896, Johannes Brahms and Clara Schumann exchange more than four thousand letters; almost all of these letters are destroyed in April 1897 by Brahms a few days before his death • "I wrote a novel, two plays and some film scripts. I believe I still have them somewhere, but it is better that no one find them"—François Jacob • Sophocles apparently authored one hundred and twenty-three plays; only seven of them have survived • In Madrid in 1927, Nancy Cunard broke up with Louis Aragon; Aragon burned *In Defense of the Infinite* and attempted suicide • We know neither where, when, nor how François Villon died • Lost, the rope given to Marina Tsvetaeva by Boris Pasternak to tie up an overstuffed valise; in 1941, the rope was used by Tsvetaieva to hang herself • Caesar composed a play entitled *Oedipus*, which is lost • *A. I. (Artificial Intelligence)*, film testament; Stanley Kubrick dies before directing it • In 1829,

Nikolai Gogol destroys as many copies as possible of his work, *Hans Küchelgarten*, very badly reviewed by the critics; in July 1845, he burns the manuscript of the second part of *Dead Souls*; the original project consisted of three parts, the third part was never begun; in February 1852, Gogol burns a new manuscript of the second part of the same book and dies shortly after • Because it was done principally on wood, nothing remains of Greek painting from antiquity • In 1899, the Spanish demand Goya's remains, dead and buried in Bordeaux in 1828; the body, without the head, is returned to Spain • The first, unfinished version of Jean Giono's *The Song of the World* was stolen from him in 1933 • Two notebooks are missing from Sylvia Plath's *Journals*: one lost, the other destroyed by Ted Hughes • The autobiography of Agrippa is lost, as well as his treatise on geography • On December 10, 1853, a fire ravaged the warehouses of Harper, Herman Melville's publisher, and destroyed the entire stock; demand was weak and no novel by Melville would be reprinted

in his lifetime • During the German occupation of Paris, Jacques Decour assembles the texts of the first issue of *Les Lettres françaises*; when he is arrested, his sister burns all the manuscripts • The oldest version of the legend of Tristan and Isolde, by Chrétien de Troyes, is completely lost • William Blake dies without finishing *Vala, or the Four Zoas* • On the night of the 23rd or 24th of May 1792, Lenz is found dead in a street in Moscow; an anonymous aristocrat covers the cost of the burial; no one knows where the grave is located • We know neither the place nor the date of Jeanne Duval's birth; where did she die? where is she buried? • No one knows how or when Stéphane Mallarmé met Édouard Manet • "To S. A.," the initials of a lost name, in the dedication to *The Seven Pillars of Wisdom* by T. E. Lawrence • In 1921, in a film by Marcel Duchamp, Man Ray is asked to shave off the pubic hair of the very eccentric Baroness Elsa von Freytag-Loringhoven; the film is destroyed in the course of being developed • Nothing remains of Peter Abélard's *Love Cantilenas*

• On April 19, 1859, Alexandre von Humboldt returns the incomplete manuscript of the fifth volume of *Cosmos* to his editor and dies seventeen days later • In 1944, Drieu La Rochelle begins the *Memoirs of Dirk Raspe*; the novel remains incomplete as a result of his suicide • *The Large Basalt*, a sculpture by Fritz Wotruba; buried in Vienna during the Second World War, it was never recovered • Jerry Burt says that Salinger told him in 1978 that he had written fifteen or sixteen other books after *The Catcher in the Rye* and *Franny and Zooey*: "He may have burned them all. He may have published them under another name. He didn't have any idea at the time what he was going to do with them" • The love letters of Arthur Rimbaud to Paul Verlaine • On climbing the scaffold, Ravachol sang, "The Good Lord in Shit"; we know he didn't get to the last couplet, but we no longer know at which word the guillotine actually silenced him • On his deathbed, Balzac asks Dr. Nacquart for a sheet of paper; he writes about ten lines; this final handwritten page was never recovered •

In twelve weeks, *The Silence of the Sea* by Jean Bruller-Vercors was composed at a printer's specializing in obituaries; eight pages were printed at a time; the manuscript pages were destroyed as they were printed in order to preserve only the printed pages • In 1924, the editor René Hilsum acquires twenty-four initials engraved by Louis Jou; at the request of Hilsum, Paul Valéry writes *Alphabet*, twenty-four prose texts of which the first letter of each corresponds to each one of the proposed letters; twenty-four and not twenty-six, Louis Jou having omitted two letters, K and W • Georges Perec dies without finishing being born; *I Was Born* is the title of the book he leaves unfinished • In 1947, the Pirelli Company orders a film from Roberto Rossellini for the seventy-fifth anniversary of the company; the script is one hundred and ten pages; two versions exist, a company version and a popular version; Pirelli kept neither one nor the other • In 1992, the library of Pristina, Kosovo, is ransacked, emptied by the truckload and transformed into a cafeteria • In October 1849, Edgar Allan

Poe, forty years old, dies in Baltimore as a result of an assault whose circumstances were never elucidated • The kites of Tomi Ungerer • From August 17 to September 1, 1934, Sergei Mikhailovich Eisenstein works with André Malraux on an adaptation of *The Human Condition*; the film would never see the light of day • Herman Melville extensively annotated the works he studied; a number of his notes in the margin (those concerning women) were later erased; though some strongly suspect Melville's wife, others attribute the erasures to his two daughters, Elizabeth and Frances • Dorothy Parker was cremated in 1967 (the epitaph suggested by Dottie: "Sorry for the dust"); the urn stayed at the undertaker's until 1973, the year it ended up in the office of a notary, who put it in a drawer where it was forgotten until 1988 • After twenty sketches, Pablo Picasso gives up doing the portrait of Helena Rubinstein • The painter Georges Malkine (1898–1970) is not in the encyclopedia • During his seven-year stay in Berlin, Robert Walser writes three novels; he burns them

afterward without trying to publish them • A good third of the film *Metropolis* by Fritz Lang has been lost forever • The erotic narrative, *The Life Story of a Viennese Whore, as Told by Herself* (1906), is signed with the pseudonym Josephine Mutzenbacher; the hypothesis is advanced that it was the work of the author of *Bambi* (1929), but evidence is lacking • All papers filed in the procedure against Charles Baudelaire for *The Flowers of Evil* disappear in a fire at the Palais de Justice, in Paris, in 1871 • In his notebooks, Victor Hugo sketched out dozens of beginnings for novels he never wrote • Franz Kafka dies without having finished *The Castle* • From 1928 to 1936, Luigi Pirandello works on his last play, *Mountain Giants*; he dies without finishing it • Jules Verne destroys all his personal archives before dying; it appears he was afraid his homosexual and anarchistic tendencies would be revealed after his death • In June 1999, in Cambridge, someone stole the hard drive on which, for ten years, fifteen researchers had archived Ludwig Wittgenstein's ideas on politics

and language • The Villa Diodati, which overlooks Lake Geneva and where Mary Shelley wrote *Frankenstein, or the Modern Prometheus* in 1816, was sold at auction on September 30, 1996 • On May 26, 1924, Virginia Woolf notes in her journal: "My thoughts are completely occupied by *The Hours*"; the novel would never be written • Meret Oppenheim, annoyed by the success of her *Object, or Breakfast in Fur* (1936), destroys all her works after the war • On January 14, 1964, the first novel of Sylvia Plath, *The Bell Jar*, is published under the pseudonym of Victoria Lucas; her *Journal* mentions two other novels, *Falcon Yard* and *Double Exposure*; both manuscripts are missing • *The List of Transparencies*, text by Henri Lefebvre and linocut by Marie-Noëlle Gonthier • The paintings of Jean-Claude Pirotte, Belgian painter and writer, are lost • In 1897, Robert Musil tries his hand at poetry, writes some dramatic sketches, but no trace of this work remains; in June 1911, Musil works on a satirical project, *The Land Over the South Pole*, which will never see the light of day;

The Man Without Qualities remains unfinished • "Maurice Rheims brought me a letter by Vigny, I also received some cashmere socks, I put everything in my pockets, it has disappeared with the rest"—Bernard Frank • Paul-Armand Gette destroyed *This Day Will Ripen in the Garden of Eros*, the picture that he presented at the IntERnational ExhibitiOn of SurrealiSm 1959–1969 (**EROS**) • The American filmmaker Robert Kramer wrote several novels that were never published • In 1952, Stravinksy met Dylan Thomas in New York to discuss an opera that would never see the light of day • On December 14, 1999, in a library in Armargh, Northern Ireland, two men stole a rare edition of *Gulliver's Travels*, two hundred and seventy-three years old and annotated in the hand of its author, Jonathan Swift • Ruan Lingyu, Chinese actress (1910–1935), performed in many popular films; most of these films have disappeared • Pascal Pia destroys two manuscripts in 1924, *The Barriers* (novel) and *The Bouquet of Nettles* (poems), to the stupefaction of Gaston

Gallimard, who was preparing to publish them • About ten thousand Verdier Editions books were lost during the floods in southern France on November 12 and 13, 1999; the editor had stocked his books in Lagrasse, a disaster zone • Valery Larbaud, who kept a journal all his life, destroyed most of it; some years survive, mostly 1931–1932 and 1934–1935 • In a fit of rage, Egon Schiele's father, stationmaster at Tulln, burned all of his son's drawings representing railroad cars • Ernst Pfeiffer, the last companion and confidant of Lou Andreas-Salomé, dies keeping the secrets that she did not want revealed • Friedrich Dürrenmatt burns the final version of *The Tower of Babel* on December 13, 1948 • At Arezzo, *The Legend of the True Cross* by Piero della Francesca; sixty square meters of the fresco were completely lost, twenty square meters were saved • Jude Stéfan sent his first manuscript to Maurice Blanchot; accepted by Gallimard, the manuscript was left in a taxi by Jean Paulhan • *It's All True*, a film shot in Brazil in 1941 by Orson Welles, was never completed •

Rudyard Kipling, who spent a good part of his life working on *The Book of Mother Maturin*, ended up completely abandoning it • The composer Max Deutsch mercilessly destroyed his musical scores, having chosen to leave no trace other than his teaching • Sophie Calle: her childhood bed burned up in a fire • After the crash of 1929, Howard Fast moves to the south of the United States; he produces six novels about his experiences, destroying five of them and finally publishing the sixth, *Two Valleys*, before the age of nineteen • Diego Rivera came to New York to undertake a commission at the Rockefeller Center; in his mural he depicted the triumph of Marxism over capitalism and drew a portrait of Lenin; his mural was destroyed • In 1913, the first *ready-made* by Marcel Duchamp appeared: *Bicycle Wheel*; the "original" is lost • *The Field of May* by Pierre Oster; missing a comma on page 124, line 7, after "until here" • *A Dance to the Music of Time*, which is the title of a painting and of a long written work composed over twenty-five years, has no ending (if

not that of its respective creators: the painter Nicolas Poussin, who died on November 19, 1665, and the writer Anthony Powel, deceased March 28, 2000) • *The Fish* by Ingmar Bergman and *Mastorna*, the first film by Fellini, were never shot; *Capital*, the unfinished film of Sergei Eisenstein based on "the screenplay" (sic) by Karl Marx • *Life of Cato*, composed by Cornelius Nepos, is now almost entirely lost • Velazquez's composition, a commissioned subject that depicts the expulsion of the last Moors in Spain, burns in a fire at the Alcazar in 1734; the equestrian portrait of King Philip IV as well as a number of works from a series representing dwarfs and clowns, disappear in their turn in different fires at several other royal residences • The pregnancies of Frida Kahlo • The glory of Jacques Sternberg and the bookstore *The Minotaur* • *Livre pour quatuor for stings* by Pierre Boulez has never been performed in its entirety; the fourth movement remains in the archives of the Sacher Foundation at Bâle • "Villa Nomad," Raymond Roussel's mobile home, disappeared without a trace after

(21)

it was shown and offered up for sale • *Tilted Arc*, a monumental, site-specific work by sculptor Richard Serra; commissioned in 1981 by the U.S. Government for the Federal Plaza in New York, it was dismantled in 1989 by its commissioner • In 1917, Leos Janácek decided to write the *The Diary of One Who Disappeared* based on an anonymous text • *The Golden Apples* and *Toilet on the River*, two installations by Ilya Kabakov • Missing from Jules Renard's *Journal*, the passages suppressed by his wife; missing from Nietzsche's *Will to Power*, the passages suppressed by his sister • During her cousin's life, Madeleine Gide burned the correspondence of André • *Trans-Europe-Express* by Alain Robbe-Grillet, unfinished cine-novel • The letters of Proust torn up by Marie-Laure de Noailles (six years old) • The "Seventh Song" of *Maldoror* • *The Road to Sèvres* by Corot, missing from the Louvre in 1998, has never been found • In 1940, the Gestapo sacked the Parisian apartment of Saint-John Perse and destroyed his manuscripts • *Dig My Grave with a Golden Spoon*, a play by

(22)

Frank O'Hara • With the possible exception of *Saint Francis in Ecstasy Supported by Two Angels*, the work of the painter Jacques de Bellange has completely disappeared • In June 1946, Raoul Hausmann and Kurt Schwitters began a correspondence and planned the creation of a journal, *Pin*, which would never see the light of day • The anticipated finale in D disappeared from the first section of *Offertorium*, Sofia Gubaidulina's concerto for violin • The *Self-Portrait* of the Douanier Rousseau, corrected and completed by Grosz and Heartfield, is lost • In 1945, the deaf Japanese photographer Koji Inoue loses his negatives in a bombardment he does not hear • Erich Wolfgang Korngold abandons the composition of his second symphony for good after two attacks of apoplexy • James Joyce and John Milton wrote their masterpieces, *Finnegan's Wake* and *Paradise Lost*, while losing their sight • In 1964, Marcel Broodthaers destroys the fifty unsold copies of his book of poems, *Pense-Bête*, by dipping them in some plaster; his first sculpture • *On the Road*: the final seven meters of

Jack Kerouac's original typescript were eaten by a dog • One night in April 1994, the manuscripts, pictures, and rare books of Lesley Blanch, British writer and spouse of Romain Gary, were lost in her burning house • The oeuvre of Shirley Clarke, American filmmaker, fell into oblivion • Henri Michaux loses his muse in February 1948, accidentally burnt alive • In 1909, William Carlos Williams publishes *Poems*, his first collection; four copies are sold, the others disappear in a fire • Seven hundred polaroids of Philippe Chevallier (portraits of young women in tights) were stolen in 1990 by an unscrupulous female friend • Around 1860, Mussorgsky abandons his opera *Salammbô* • At Franzensbad, where Elsa Triolet was being treated, the hotel burns down, taking the manuscript of her novel *Camouflage* along with it • In 1924, Anaïs Nin starts writing her second novel, *The Blunderer*, and gives up after a few pages • The painter Max Liebermann painted four identical pictures entitled *Cart in the Dunes*; the fourth version was lost • Until 1977, New York artist Jenny

Holzer paints on canvas in the style of Mark Rothko; nothing remains of this period; a text by Jenny Holzer, created for the 1982 Documenta exhibition at Kassel and painted on the facade of a building, is erased in May 2002 when the new owner of the building decides to have the facade restored; he did not know it was a work of art • Michel Butor is not present in a group photo of the writers of the Nouveau Roman, taken in front of Éditions de Minuit in 1959 • The Tenth Symphony of Gustav Mahler is incomplete • The first *Nana* by Niki de Saint Phalle; no doubt, accidentally destroyed, it has not been seen since it was stored at the Georges Pompidou Center • For the 4% of the population afflicted with a congenital inability to perceive music, Mozart no longer exists • Inspired by *La Jetée* by Chris Marker, *La Rejetée* by Thierry Kuntzel is a film made up entirely of photograms; the original film rolls of the work were lost • The printed copies of Laurence Sterne's *A Political Romance* were burned in 1759 on the bidding of the magistrate Topham (five or six copies were saved

(25)

through negligence) • Conscripted into the German army and traumatized by the First World War, Ernst Ludwig Kirchner paints *Selbstbildnis als Soldat* and stops painting for two years; he kills himself in 1938 • Forty-two works by Vermeer have come down to us, the others are missing; there isn't a single line written in his own hand or one self-portrait • Jean Giraudoux: "Plagiarism is the foundation of all literatures except the first, which is unknown" • Alexander Dumas, fils, possessor of the letters of George Sand to Frédéric Chopin, returns them to their author, who destroys them • The body of Heinrich Mann was transferred alone to a cemetery in East Berlin; the remains of his wife, Nelly, were forgotten in the West • Henri de Toulouse-Lautrec wasted the last two years of his life by not painting • Of the sixty copies of *The Prose of the Trans-Siberian* published in 1913 by Blaise Cendrars, forty-five are missing today • A drawing by Leonardo da Vinci representing Orpheus pursued by the Furies, which was part of the *Codex Atlanticus*, is destroyed in

December 2001 while it is being restored • Seventy-five choreographies of Georges Balanchine have been identified; the rest have disappeared, and Balanchine does not regret it • Of Aeschylus's Promethean trilogy, only *Prometheus Bound* survives; some fragments of the second play, *Prometheus Unbound*, are known, but the third part, *Prometheus, Fire-Bearer*, is completely lost • The great Buddhas of Bamiyan • The Review of the UnWritten Book, www.olywa.net • Arletty's nude scene was removed from the final version of *Daybreak* by Marcel Carné • Tintin's bedroom doesn't appear in a single album by Hergé • *The Lover* by Marguerite Duras: a work constructed around a missing photo; *She Is There*, a play by Nathalie Sarraute: the story of an idea we will never know • The Regional Center for Contemporary Art in Corte, Corsica, burns down; a hundred works of art go up in smoke, including those by Dan Graham, Carl André, Sophie Calle, and Annette Messager • In April 1936, the manuscripts of Victor Serge are confiscated on the orders of

Stalin • Three hundred works by Auguste Rodin, a tapestry by Joan Miró and Josep Royo, a canvas by Lichtenstein from the *Entablature* series, a sculpture by Calder, a painted wood relief by Louise Nevelson called *Sky Gate New York*, some works by Mariko Mori and by Goldsworthy, forty thousand photographic negatives by Jacques Lowe, in the ruins of the W.T.C. of New York, September 11, 2001 • Valéry Mréjen's ex-lover, known as "l'Agrume," lost a screenplay on a train of the RER B line • The original *Peg-Top*, a painted bronze by Hans Bellmer • *Satires* by Jude Stéfan: the manuscript accepted by Georges Lambrichs in 1963, misplaced, will never be published for lack of a copy • Influential surrealist "poet" Jacques Vaché never wrote a thing • Jean Dubuffet destroys most of his canvases in 1924; around 1950, he falls out with Jean Paulhan and burns the quasi-totality of letters received from him; on his death he leaves behind an unfinished manuscript, *Bâtons rompus (Meanderings)* • Issue VI of *Troisième Convoi*, Jean Maquet and Michel Fardoulis-Lagrange's

journal • She loses when she loves: scarves, dolls, rings …; the Hungarian poetess Krisztina Tóth took an inventory of her losses in *The Scribe of Lost Objects* • Since Ovid's error was never put in writing, the reason for his banishment by Augustus has remained unknown for the last two thousand years • Destroyed during the Second World War, houses in Frankfurt and in Leipzig where Goethe and Wagner were born • *Drawing, 1966*, 150 x 120 cm, lead pencil on craft paper, by Pierre Buraglio, is lost • *Robinson Library*, written by Jorge Luis Borges, was never published • Burned, the diary of Thomas Mann covering the years 1900 to 1910 • In Vladivostok, the city where Osip Mandelstam is said to have died (no one is sure of this), a cast-iron statue representing the poet was lost, a victim of metal looters • The Danish essayist and short story writer Villy Sørensen completes his first novel at sixteen and destroyes it at seventeen • William Burroughs had no memory of the writing of *Naked Lunch* • In her film *Scarlet Diva*, Asia Argento requires non-simulated sex from her actors and

then cuts the scenes during the editing • Rue Beautreillis in Paris: the bathtub in which Jim Morrison died has been destroyed • Seventy-eight woodcuts by the Albanian painter Maks Velo are definitively lost • In the 1960s, in Poland, the sculptor Igor Mitoraj burns all of his canvases • Pierre Louÿs started to write a *Treatise on Sodomy*, which he left unfinished • In 1918, Arthur Cravan marries Mina Loy and is lost at sea • Of the considerable oeuvre of Pindar, only four collections of Victory Odes, the *Epinicia*, have survived • As part of an inheritance, the family of Manet divides up the painting *The Execution of Emperor Maximilian*; Degas saves a part of it, the others go missing • Edvard Grieg was planning to write a monumental opera, *Olav Trygvason*, based on the poet and dramatist Bjørnstjerne Bjørnson's libretto, which does not get beyond the first three scenes; lacking a complete libretto, the work remains unfinished • The play, *The Baphomet*, which inspired Pierre Klossowski, was never performed in the century that produced it • Lost, a sonata composed by Jean-Paul

Sartre • Destroyed, the first two paintings on paraffin by the Belgian painter Claude Panier • The pianist, Arcadi Volodos, makes a record entitled *Schubert* at Vienna's Sofiensaal concert hall, which burns down a month later • The only plan of Gaudí's *Sagrada Familia* was destroyed during the Spanish Civil War • Galina Oustvolskaya, Russian composer, practices self-censorship to the point of destroying her works • Christian Boltanski creates an installation, *The Missing House*, on the lot of a missing (bombarded) house between two buildings on Grosse Hamburger Strasse, Hamburg • Most of the negatives of German photographer, Aenne Biermann, dead at thirty-five in 1933, have disappeared • Rebecca Wilson lends her face to the artist's likeness, but no one knows Netochka Nezvanova, who posted *Nato. 0 + 55* on the internet • Written in Egypt under the XII Dynasty, the first part of the stories of the *Westcar Papyrus* is missing • The canvases of Francis Bacon that were in Peter Beard's possession, several volumes of *Diaries*, and some travel notebooks were all destroyed

in the fire at the artist's millhouse at Montauk, Long Island, in 1977; Christian Liaigre possesses a single photo of the same Peter Beard, of which the negative is missing • As a student, Ezra Pound wrote a sonnet every day and destroyed all three hundred and sixty-five poems at the end of the year • Willem de Kooning's drawing, erased by Robert Rauschenberg • The first version of the novel by Malcolm Lowry, *Under the Volcano*, written in the United States, is rejected by editors; the second version, rewritten in Canada, is forgotten in a bar in Mexico; Lowry loses the third version in a fire at his house • In 1961, the sculptor Arman pulverizes a contrabass in front of Japanese television cameras; in 1975, he destroys, with an axe, a bourgeois interior reconstructed in a New York gallery; in March 2001, he dynamites a sports car at Vence; on June 15th of the same year, he bulldozes a living room installed in the museum of contemporary art in Nice • Every two years the painter Philippe Hélénon burns sixty "cumbersome" canvases in his garden • Chekhov's *Platonov* was never

staged during the author's lifetime • Act IV of the last play of Federico Garcia Lorca, *El Publico*, has disappeared • Most of the original films of experimental filmmaker Oskar Fischinger have been lost • In the autumn of 1930, Bertolt Brecht and Walter Benjamin plan on founding the journal *Krisis und Kritik*, but the project never gets off the ground • Teatro La Fenice, ravaged by fire on January 29, 1996 • There are only three words remaining of the Cumbrian language, which was related to Gaelic and disappeared around the seventh century CE (Jacques Roubaud will compose some poems using the last three remaining words) • The preface that Strindberg refuses to write for an exhibition catalogue on Paul Gauguin • *The Self-Portrait on the Road to Tarascon*, painted in 1888 by Vincent Van Gogh, and belonging to the Magdeburg Museum in Dresden, was destroyed during the Second World War • As the first director of Goethe's house at Weimar, and to help his students develop a new appreciation of the past, Gerhard Scholz, as part of an auto-da-fé, burns the last

preserved article of Goethe's clothing, a bathrobe riddled with moth holes • In 1910, Roger Martin du Gard publishes *One of Us* with Grasset and, during the war of 1914–1918, pulps the unsold copies; this work will never be reissued; in December 1931, unhappy with his work in the year of 1930, R.M.G. burns the manuscript of *Setting Sail*, a volume initially intended for *Les Thibault* • The Sixth Biennale of Contemporary Art in Lyon presents an untitled film about a nameless German soldier, a wartime landscape painter killed in combat • Two works by Picasso painted on Yvonne Zervos's hands, May 23, 1937, washed since then • Destroyed, the canvases of the painter Alberto Greco, which he threw under the wheels of cars while screaming "Long live living art!" • We no longer know why Henri Lefebvre fell out with Guy Debord • *The Merzbau* (1920–1936) by Kurt Schwitters, sculpture-décor constructed in his house in Hanover, is destroyed after he goes into exile • *The Vegetable Kingdom*, a work by Roger-Edgar Gillet, disappears with the death of the

collector Janssen; he will be buried with it • *Bouvard and Pécuchet*, unfinished novel; finished, it would have no ending because there is no end to the stupidity of human beings • The letters of Lou Andreas-Salomé destroyed by her lover Frieda von Bülow; the letters of Frieda to Lou with either their beginnings or their endings amputated; Lou (at seventeen) leaves no written trace of a liaison with the priest Hendrik Gillot (forty-two) • "Monsieur A. continues to prohibit the viewing of my films (…) For twenty-five years he has prevented the public from viewing *El Topo* and *The Holy Mountain*. Monsieur A. destroyed the original negatives (…)" Alejandro Jodorowsky, ambalefada@nomadsland.net • Stolen and unrecovered, the main body of Japanese painter Morio Matsui's collection • From 1933 to 1936, René Etiemble prepares a thesis, *Taoist Metaphysics and Physical Culture*, never completed • No one knows why Donald Goines, black American novelist, was assassinated in October 1974 • Seaside studio-cabin of painter Richard Texier, destroyed in the storm of 1999 • From the

(35)

train that took him to Buchenwald, the father of Martin Monestier, managed to send a letter to his wife who forwarded it to their son; Martin Monestier, who didn't want to know the contents of the letter, never opened it • Painted in 1973 in Santiago, Chili, in the popular quartiers of La Cisterna and La Granja, two frescoes by Roberto Matta are destroyed after the coup d'état led by General Pinochet • Part of the *Altarpiece of the Teutonic Knights of Sarrebruck* by Jost Haller has completely disappeared • Aretha Franklin loses archives and mementoes in the fire at her house in Detroit • Most of the works of Zdenek Pešánek, Czech precursor of lumino-kinetic art, no longer exist • In 2002, the authorities in Hanoi order the destruction of 15,668 pirated books of "toxic content" brought into the territory via the internet • A diary of Richard Burton was stolen from the local headquarters of the BBC in London • In September 1967, Jacques Tati turns over his screenplay of *Playtime* to the bulldozers that were bringing down the film set • The Oslo Library

refused to make public the psychoanalysis of writer Knut Hamsun, recorded in shorthand in 1926 • A woman spreads her fingers around an object that no longer exists: *The Invisible Object*, a sculpture by Alberto Giacometti • The original floor-plan of the permanent collection of MASP, the Museum of Art of São Paulo, is now destroyed • During the summer of 2001, Mâkhi Xenakis creates a "successful" work that she destroys on the grounds that it "doesn't represent her family" • The Tate Britain is deprived of the Tracey Emin 2002 Christmas tree: Emin offered it, instead, to AIDS patients in the West End of London • We know only two landscapes by Edgar Degas, the photographer: two prints removed from a long, lost series • From the Sixteenth to the Seventeenth Centuries, the "iconoclasm of the Reformation" leads to the destruction of a considerable number of religious works of European art • Abandoned in a studio since its inventor's death, Dieter Roth's chocolate sculpture is inexorably deteriorating; Roth sought the sculpture's total disappearance; it'll go fast • *The*

Oresteia, the condensed myth of the Atreides, a libretto by Heiner Müller commissioned by Pierre Boulez • Richard Long's *River Avon Mud Hand Circles*, a mural painting shown at the Daniel-Templon Gallery, erased on May 27, 2001 • *Oboe Concerto* by Ludwig van Beethoven • The books and manuscripts of Theodor Mommsen, lost with the burning of his house; tome VI of his *Roman History* remains unfinished • Pedro Almodóvar is born at Calzada de Calatrava in 1949 or 1951, we don't know; the birth date of the sculptor Guy Peellaert is not known or is kept secret by him • Bombarded forty times and forty times rebuilt, Belgrade has lost almost all of its original architectural character • "This novel/ I immediately rejected it I threw it out/ I have thrown out more novels than I have published/ to say nothing of all the rest of the prose/ that I have written and thrown out/ and which I have not published"—in *Buys Himself a Pair of Pants and Joins Me for Lunch* by Thomas Bernhard • The name of the imbecile who interrupted the life of Roland Barthes and the novel *Vita Nova* by

the latter, victim of the hit-and-run • Isabelle Garron's suitcase, stolen in Marseille in 1997, which contained the manuscript of an untitled novel • George Oppen's first collection of poems is published in 1934 and the poet stops writing for twenty years; for thirteen years Verdi doesn't write a single opera; Rossini abandons composition at forty; Mozart didn't produce anything in the year 1790; Strindberg called the seven years during which he could not write a word an "Inferno Crisis"; before writing *A Throw of the Dice Will Never Abolish Chance*, Stéphane Mallarmé had renounced publishing for ten years; during divorce proceedings with Olga, Picasso stops painting and tries his hand at writing • Only once in his life did André Malraux exclaim: "I believe, for a minute, I was thinking nothing" • We don't know what the Marquis D.A.F. de Sade looks like; his portraits are lost • Some texts by René Descartes are lost, among which is the important *Olympica*, where he noted his dreams • Not a single love song was composed by Rutebeuf • Ten thousand five hundred films made

with nitrate film before 1950 in the United States have self-destructed • The chalk drawings on blackboard by Francis Picabia • *Über die neuere deutsche Literatur* (1767–1768) and *Kritische Wälder oder Betrachtungen, die Wissenschaft und Kunst des Schönen betreffend* (1769), published anonymously • François Weyergans's *Flesh Color*, a feature film unedited since it was directed in 1979 • In 1904, James Joyce gave three public lectures in Italian at the Università Popolare di Trieste; a page of text from one of these conferences on Giacomo Clarenzio Mangan was lost • In the seventeenth century, the manuscripts of printed works are systematically destroyed • Inspired by a film for teenagers, sculptor Dan Graham writes a rock opera in 1987 that has never been performed • *Biathanatos* was never seen by its contemporaries; In it, John Donne supported the thesis that Jesus Christ committed suicide, but refused to publish the book during his lifetime • *I Am Blood*, a play by Jan Fabre, written and conceptualized for the *Court d'honneur* in Avignon and performed for four nights running, will

never be performed again, in accordance with the author's wishes; for eternity and by bequest, the theatrical works of Thomas Bernhard is prohibited from being performed on Austrian soil • The work of the mature Jean-Germain Drouais, Louis David's favorite student, who dies at twenty-four in 1788 • All copies of *Parvaz* (*The Flight*), the first magazine designed by Iranian photographer Reza, were destroyed by the Revolutionary Guard • Jean-Pierre Melville enlists writer André Héléna to make a feature film; Héléna refuses to shoot it in the United States and so the film isn't made • "I cannot imagine anything significant if nothing is sacrificed, burned, destroyed (...)" proclaims Otto Muehl; this he did and does, since then and ever after • Isolated during his life, Czech philosopher Ladislav Klíma has not been included in dictionaries of philosophy since his death in Prague on April 19, 1928 • In August 1940, the library of Ivan Turgenev, in Bougival, included a hundred thousand volumes; in September of the same year the works were stolen, burned in Germany, or

dispersed in the Soviet Union • *The Khovantchina*, unfinished opera by composer Modest Mussorgsky • Casein, wax and ammonium carbonate are component elements of the mixtures used by Balthus, but the precise formula is now permanently lost; François Rouan, who prepared them for him, will not divulge his secret • Missing, the conclusions to the opera *Die Drei Pintos* by Carl Maria von Weber, the Third Symphony of Anton Bruckner, and the *Suite aus seinen Orchester Werken* by Jean-Sebastien Bach • On May 29, 2002, three million books go up in smoke in the warehouse fire of publishing company, Les Belles Lettres, in Gasny in the Department of the Eure; go missing: Chinese texts of the Ming period, the complete works of the Italian philosopher Giordano Bruno, the *Corpus Flaubertianum* (a diplomatic edition of Gustave Flaubert), a first bilingual edition of the texts of Shakespeare, six hundred leather-bound, limited editions of Budé (1921–1960), all or part of the archive of forty-five publishers including Unes, Fata Morgana, Chandeigne, L'Escampette •

(42)

Photo and video documentation, as well as sketches by graffiti artist Espo, seized by police during his arrest, and which he will never see again • *Garbage, the City and Death* by Rainer Werner Fassbinder: in 1974, the publisher Suhrkamp withdraws the text from sale and from his catalog and decides to destroy the printed copies • Senior official, theater and film critic, Bernard Dort, abandons writing his first and last novel in 1953 • The library at Alexandria in 47 BCE • Out of fear of another fatwa, Roland Jacquard's *In the Name of Osama Bin Laden* is published without identifying the press • There are two manuscript copies of the *Jena Symphony*, one signed by Ludwig van Beethoven, the other by Freidrich Witt; we still do not know who is the actual author of the work • Nico Papatakis wants to make a film adaptation of *The Question* by Henri Alleg, with Jean-Paul Sartre writing the screenplay and Alain Resnais doing the camera work, but the project is abandoned • The journal *Die Fackel*, created and directed by Karl Kraus, in Vienna, is scuttled in 1933 with the

rise to power of Adolf Hitler • We do not know the true identity of Miss-Tic; the artist loses eight years of work in a fire at her studio, publishes *Just Passing Through*, now out of print • Published in the thirties, *The Devil's Popess*, an erotic novel authored by Jehan Sylvius and Pierre de Ruynes, is probably the collaboration of Ernest Gengenbach and Robert Desnos, but nothing is certain • In a tavern in Deptford, Marlowe, twenty-nine years old, was assassinated on May 30, 1593; we have no idea who ordered his elimination • The Firminy urban project was intended to include a civic center and three residential units; Le Corbusier dies, the site remains unfinished • Envisioned by Strindberg, publication of an *Illustrated Report on the Writer August Strindberg* will never take place • The Monet painting, *Water Lilies*, burnt in a museum in New York • The actress Frances Farmer showed no clinical signs of madness • The journal *Le Grand Jeu* released three issues between 1928 and 1932; a fourth issue was never published • *Portrait of a Young Woman, La Fornarina*, an unfinished

painting by Raphael • In an attempt to inventory its artistic holdings, the BBC asks its employees to return any lost works they may have "borrowed," with no response or restitution since • Jules Massenet composes *Sappho* based on a text by Alphonse Daudet; the "Scene of the Letters" is lost • During the Second World War, in Grunewald, near Berlin, the home of the physician and musician Max Planck is bombed; his library, his journals, and his entire correspondence are destroyed • Between 1994 and 1996, four hundred sixty-six antique books, ten of which are incunabula, disappear from the library of the Diocese of Zamora, Spain; in 2001 five hundred books from the Historical Library of Teresiana (Mantua), closed to the public for two years, go missing • Jean Genet and Bertrand Tavernier once tried to make a film together • The large oils on reinforced canvas that decorate the station of the PLM line (Paris-Lyon-Méditerranée), paintings completed by the workshop of Genovesio-Lemercier in the eighties, were made in the twenties by artists whose names are

now lost to us • To prevent posterity from looking too closely at his working methods, Chateaubriand systematically destroys his manuscripts; a few copies escape his vigilance and are spared from the fire • In 1938, the Brazilian military junta burns Jorge Amado's books in a public square in Bahia, his hometown • The Polish painter and grandmother of Belgian filmmaker Chantal Akerman loses all her paintings • Missing, five episodes of *Napoleon* by Abel Gance; for lack of funds, a single, five-hour episode is shot; for a month the director makes daily visits to Céline in Meudon to work on a treatment of *Journey to the End of the Night*, a film that would never be made; Antonin Artaud was to have starred in Abel Gance's film *The End of the World*, but he refused to perform in a talkie • The Avignon Festival, 2003 • Serge Gainsbourg destroys his own paintings, with the notable exception of a self-portrait • *Absent Names*, an installation by Pedro Cabrita Reis presented at the 2003 Venice Biennale; *Lost* (sign lettering, 1994), the work of Jack Pierson • All the poetry of

Cicero, from youthful works to the dedicatory poem for his consulate, has been lost • *The Assumption of the Virgin* by Albrecht Dürer, 1509, from a triptych commonly called The Heller Altar, was destroyed in a fire; the large-format woodcut, *The Triumphal Procession*, was never completed • The original memoirs of François de La Rochefoucauld are stolen from him; rewritten by one or more unknown persons and published without his consent, La Rochefoucauld later disavows the work • Only some sketches remain of Peter Paul Rubens' project for the Henry IV gallery in Paris around 1622 • It is said that Terence wrote a hundred and thirty comedies that are lost to us • After the Salon des Indépendants in 1863, Auguste Renoir destroys *Esmeralda*, which he was exhibiting; his silhouette of Mürger, painted on the wall of the inn at Marlotte, is later covered over by a distracted worker; the 1872 paintings *Source* and *Buglers on Horseback* [*Trompette de guides à cheval*] have disappeared; Renoir preferred the actress Jeanne Granier to Sarah Bernhardt and wanted to paint her but

never did • Mercedes de Acosta Hernandez y de Alba wanted to make a film about her liaison with Greta Garbo; Irving Thalberg rejected the scenario • *The Coronation of Saint Nicolas of Tolentino*, an altarpiece completed in 1500 by Raphael (at seventeen) for the church Sant'Agostino in the Città di Castello, is later destroyed, for the most part, by an earthquake • Of fourteen scientific treatises attributed to philosopher and poet Omar Khayyám, only two books have survived • Jules Laforgue dies, leaving the poem *The Isle* unfinished • *The Lady of Carouge*, a verse drama by Gérard de Nerval, was never performed and the manuscript was lost • Missing from the filmography of Andrei Tarkovsky are three works he was unable to produce: *Hoffmanniana*, *Light Wind* and *Sardor* • The roman fantastique *The Consequences of the Reformation* and a book on Herman Hesse by Dadaist writer Hugo Ball have beeen published; his study of church demonology in the Middle Ages remains unfinished • The works of Wassily Kandinsky that were left in Russia at the time of his departure for

Berlin in 1921 have disappeared • *The Bloody Nun*, an unfinished opera by Hector Berlioz • The lounge designed by Mondrian in 1926 for the collector Ida Bienert in Dresden was never built • Alban Berg dies on Christmas, 1935, leaving Act III of *Lulu* unfinished, as well as a vocal piece for piano, a symphony, the *Third String Quartet*, and some film music • *The Pit and the Pendulum*, the first opus of Stephen King • The New National Theater, The Temporary Guggenheim Museum in Tokyo, The Museum of Human Evolution in Burgos, and The Congressional Palace of A Coruñā, all unfinished projects of the architect Jean Nouvel • Lessing abandons writing a play on the suicide of Seneca • The National Museum in Kabul holds over one hundred thousand pieces at the time of its glory, but it burns down in 1994; over fifteen days in April 2001, the two thousand seven hundred and fifty pieces that had been miraculously spared up to that point are destroyed by representatives of the Ministry of Vice and Virtue with sledgehammers, axes and crowbars • Most of the

(49)

works of Daniel Buren, creator of the concept of "in situ," are destroyed after being exhibited • On October 24, 1978, Jacques Roubaud drafts the three-part outline for *The Warburg Library* [*La Bibliothèque de Warburg*], a monumental text for which seventeen years of work were anticipated; the following night, he tears up the outline • In the summer of 1851, at the request of the Commission on Historical Monuments, Baldus, Le Secq, Bayard, Le Gray and Mestral photograph the most beautiful buildings of mainland France; two hundred and fifty-eight proofs and negatives are submitted to the Commission, Bayard's photographs have never been found • Stored in a cellar used as a nuclear bomb shelter, ninety-five of the hundred and fifty photocopied *Selections from the History of Cinema* by Jean-Luc Godard were destroyed by floods in October 2000 at Locarno • In January 1912, Franz Kafka collaborates on a novel with Max Brod, *Richard and Samuel*, which will remain unfinished • Five of the six panels of the original wall paintings exhibited at La Coupole and

created by young artists of the Ladder Club in the fifties have completely disappeared • In *The Roses of Atacama*, Luis Sepulveda ponders his "inventory of losses" • Net Art: any work of virtual art is hereby condemned to disappear • During the nineties, out of self-censorship and fearing the fundamentalists who had just attacked the writer Naguib Mahfouz, Egyptian photographer Levon Boyadjian, known as Van Leo, burns hundreds of transparencies and negatives of female nudes • Antoine Percheron dies of a brain tumor without completing *Vegetable*, his first and last book • The identity of the "Unnamed," the young woman loved by Augustine and repudiated by him before his conversion • *L'Ecume des Pages* bookstore in Paris burns down on the evening of February 22, 2002; ten thousand volumes go up in smoke • Not a single painter has left a portrait of Louise de Coligny, also known as Lou, Apollinaire's lover; Lou saved Apollinaire's letters, but destroyed those she'd sent to him, after he'd returned them to her for safekeeping • The last part of the *Three Mothers* trilogy by

filmmaker Dario Argento (*Suspiria*, *Inferno*) was never shot • In May 2002, Patrice Quéréel, president of the Duchamp Foundation, inaugurates the first cemetery for missing (deceased) works of art on the grounds that "they are mortal like men" • *Madeleine of France, Queen of Scotland* by Corneille de la Haye, *Sleeping Shepherd* by François Boucher, *Sybille, Princess of Cleves* by Lucas Cranach, *The Hidden Meaning of Flowers* by Jan van Kessel, *Cheat Profiting from his Master* by Peter Bruegel, *Landscape* by Claude Joss de Monper, *Two Men* by Antoine Watteau … about sixty works stolen by Stéphane Breitwieser were finely chopped up by his mother who then threw them down the garbage chute every Friday of the week • We will never know the exact date of the death of the writer Pierre Siniac, discovered lifeless about a month after he began to die • *Laughter in the Dark*, a film by Tony Richardson, interrupted by Richard Burton's departure after eight minutes of filming • Bernini was building two clock towers for the Pantheon and one of the two

towers (begun by Carlo Maderno) surmounting the façade of Saint Peter's in Rome; under Pope Innocent X, his detractors had the unfinished work knocked down • Novalis did not see his novel *Henry of Ofterdingen* published; he finished the first part and left only short fragments of the second • The library of the Louvre, burned in 1871 • Auto-da-fé of *Conclusiones* by Giovanni Pico di Mirandola in August 1487 • Of Tasso's work, the poems *Creation, The Seven Days of Creation*, and *Monte Oliveto* remain unfinished • The films of Robert Desnos, Antonin Artaud, Philippe Soupault, Louis Aragon and Salvador Dalí remain almost entirely in the scenario stage; three films by Jacques Rivette, including *Year II* and *Phoenix*, were never shot • At thirty-five, the revolutionary Louise Michel begins writing an opera, *The Sabbath Dream*, then abandons it • Émile Zola destroyed the letters Paul Cézanne addressed to him; in 1861 Paul Cezanne destroyed a portrait-in-progress of Émile Zola: "I just smashed your portrait; I wanted to touch it up this morning, and as it got

worse and worse, I destroyed it"; by the same, *Woman Checking for Fleas* [*La Femme à la puce*] and *Afternoon in Naples* (or *The Grog Wine*), both of 1863, are lost; in 1890, the painter lacerates with a knife, retouches, and then abandons a composition of *Bathers*; as a child, Paul Junior (Cézanne's son) regularly made holes in his father's canvases where windows were represented on houses; a certain M.N. destroyed works by Cézanne by painting over canvases he did not like • Inventor of the comic opera, Plautus composes over one hundred and thirty comedies; twenty-one have been preserved • The unfinished work of Fernando Pessoa • Livy wrote a *Complete History of Rome*, a work made up of one hundred and forty-two books divided into Decades; only thirty-five books have reached us: the first, third, and fourth decades in their entirety (thirty books) and the first five books of the fifth decade • In the winter of 1959–1960, Ingeborg Bachmann inaugurates a program in poetics at the University of Frankfurt; of the six courses planned, only five were given • *Locked Drawing* [*Dessin*

Verrouillé], 1968, by Gina Pane: a metal box, welded shut, contains a drawing by the artist, permanently lost to our view • Missing, plates II and V in the first edition, 1749, of Piranesi's *Carceri* • The depot of the Cinémathèque française, administered by the Bibliothèque du film, was destroyed in a fire • *The Four Last Things*, a book Thomas More began writing in 1522, remains unfinished • In 1970, Robert Filliou offers Bengt Adlers the drawing *Meditation Bound*, representing three men with closed eyes; after Filliou's death, the central figure mysteriously disappears from the drawing • In British author J.G. Ballard's office a fake Delvaux painted by an unknown artist and based on a destroyed work by the Belgian surrealist occupies a place of honor • Rather than studying law, Petrarch reads Cicero and Virgil and his father burns up his books; Petrarch leaves some six hundred letters to posterity and destroys the rest in greater proportion; his work *De Viris* is incomplete • According to his will, still in force, the name of Frédéric Mistral is not inscribed on his tomb • A

single fragment of Heinrich Heine's *Memoirs* was published in 1884; the other parts of this work are lost • A French museum loses, or destroys, the film for an installation by Alain Fleischer: the face of a young woman projected onto the blades of a fan; for want of anything better, the museum replaces this lost image with that of the curator's secretary • Incomplete, the last novel of Brigitte Reimann (GDR) who dies suddenly in 1973 at the age of forty • During World War II, twenty-nine works by Alexander Calder, Michel Seuphor … disappear forever from the collections of the Museum of Lodz, the first European museum of modern art • In 1969, David Hockney develops a passion for the tales of Jacob and Wilhelm Grimm, reads three hundred and fifty of them, plans to illustrate twelve of them, but only illustrates six • On December 30, 1999, a painting by Picasso is stolen from the office of the director of *L'Humanité*; *Still Life with Charlotte* [*Nature morte à la charlotte*], 1924, disappears in 2004 from a storeroom of the National Museum of Modern Art in Paris • At twenty-nine,

Sigmund Freud burns all of his manuscripts • In 1944, the Berlin studios produce *Life Goes On*, the last Nazi propaganda film, never recovered • The man Peter Handke • It is not known what became of *Saint Charles Borromeo Giving Communion to the Plague-Stricken*, a work painted by Pierre Mignard for the high altar of San Carlo ai Catenari; in 1677, he decorated the small gallery of Versailles, which was destroyed in 1736; his *St. Luke Painting the Virgin* of 1695 remains unfinished • Phidias' *Statue of Zeus at Olympia* is lost; nothing but fragments remain of the decorations he executed on the pediments and on the outer and inner friezes of the Parthenon • *The Messenger*, the first film of Sergei Bodrov, Jr., disappeared with its director and film crew in an avalanche in a valley in Caucasia • Except for two receipts, no handwritten text by Molière has reached posterity • A bas-relief by Giacometti represented four legs arranged in a cross; the work was destroyed when his attention was drawn to the pattern's close resemblance to the Nazi swastika • At the fourth chapter, Pierre

Michon abandons writing his novel *The Eleven*[*Les onze*]; later, he burns his pornographic texts • Whether in life or in the novel (we no longer know), Nina Bouraoui (Nina B.) takes some photographs of Diane (D.), then tears them up "in a rage" • In the eighties, sculptor Jacques Lélut was commissioned by the French National Agency for the Recovery and Disposal of Waste to create four statues representing *Earth*, *Air*, *Water* and *Fire*; *Earth* and *Air* ended up in a dump, *Fire* was stolen, while *Water*, placed near the elevators on the third floor of the Ministry of Ecology and Sustainable Development, had its tuba stolen • In Zürich, the Cabaret Voltaire, birthplace of the Dada movement • Three mansions built by the Bauhaus at Dessau remain standing; the others, including the one by Walter Gropius, were destroyed during the war • The tomb erected near Shanghai, in which the mother of the American architect, Ieoh Ming Pei, was buried, was bulldozed during the Cultural Revolution • Jim Palette met Serge Gainsbourg, an admirer of Schoenberg, for an unrealized

project of Lettrist songs • After two years of work, Julio Cortázar abandons writing a biography of John Keats • Jacques Offenbach dies without completing the orchestration of his opera in five acts, *The Tales of Hoffmann* • Stendhal dies without completing *Lamiel* • Filmmaker Jean Vigo dies at twenty-nine in 1934; the same year, a mutilated version of his film *L'Atalante* is released • Under the communist regime, Mucha's furniture at Marienbad mysteriously disappears • Created in 1896 by the architect Odön Lechner, the ceiling frescoes and floor mosaics for the Budapest Museum of Decorative Arts were destroyed in 1920 • In 1943, the Nazis plunder three hundred and thirty-three Dutch and Flemish masterpieces from the seventeenth century collected by Adolphe Schloss, a Jewish collector from Paris; half of the collection is returned after liberation, but one hundred and seventy-two works are still reported missing • The journal that Chinese author Lu Xun, exiled in Japan, wanted to publish in Tokyo in 1906 (or 1907) to endorse the creation of a literary school would never be

realized • Janis Joplin dies on October 4, 1970; at the end of the year, *Pearl*, her unfinished album, is released • In 1936, Jean Renoir leaves the set of *A Day in the Country* without completing the film • In December 1940, Antoine de Saint-Exupéry and Jean Renoir want to adapt *Wind, Sand and Stars* to the screen; Darryl F. Zanuck, head of Fox, refuses • Of Marina Tsvetaeva's *Poem of the Tsar's Family*, only one fragment, "Siberia," has survived • The Hall of Physical Culture, created by Charlotte Perriand in Brussels in 1935 and decorated by Fernand Léger, no longer exists • *The Origines*, arranged in seven books by Cato the Elder, are lost, as well as his orations, his speeches and pleas, a book on the art of war, a book on the education of children, a medical treatise, and some letters • *Wedding Portrait of Yves and Rotraut*, 1962, a canvas created by Christo and Yves Klein, remained unfinished at the latter's death • From 1415 to 1422, Antonio Pisanello works with Gentile da Fabriano on some frescoes on the life of Pope Alexander III at the Doge's Palace; these frescoes are lost

today • The original treatise of Apicius on the art of gastronomy is lost • Roy Lichtenstein destroyed his first paintings with comic strip motifs • *Victory*, after Joseph Conrad, a film that Louis Malle wanted to make early in his career but never happened • Between fourteen and twenty-one years of age, Christian Boltanski paints more than three hundred big, "naïve" paintings, all destroyed today with some rare exceptions • The works of Grimma of the German Middle Ages, lost in the floods of continental Europe in September 2002 • *The Romanian Blouse* by Henri Matisse: eleven versions were successively erased with turpentine by Lydia, the last companion of the great artist • Jon Fante works on the scenario of *Black City* for Rod Steiger, but the film will not be made • Several writings by Tacitus have never come down to us: some speeches, some pleas, some poetry and some jokes; Book V of the *Annals* is incomplete, Books VII, VIII, IX and X are lost, as well as the beginning of Book XI and the end of XVI; of the twenty books from the *Histories*, only the first

four and the beginning of Book V remain • Most of the operas and manuscripts of Claudio Monteverdi have been lost; only the lamento of his opera *L'Arianna* survives • The house of Georges Bernanos burns down in 1940 at Fressin, Pas-de-Calais • *Happy Moscow*, an unfinished novel by Andrei Platonov • The frescoes of Giorgione, painted in oil on the walls of the Soranzo palace, the Andrea Loredano palace, and the Casa Flangini in Venice, have completely disappeared; nothing remains but vestiges of the façades of the Fondaco dei Tedeschi, which he decorated • Almost all the copies (one hundred and three) of the first edition of *Caged Rust/Enraged Balls* [*Rouilles encagées*] by Satyrmont (Benjamin Peret), published in 1954 by Eric Losfeld, disappeared in a flood • Those photographs of Henri Cartier-Bresson that would not be taken on the pretext that he had forgotten his camera or that he was too old • In 1751, Joseph Haydn receives a commission for a comic opera of which not a trace remains; twenty-six other operas followed, eleven of which are lost; his

wife, Maria Anna, cut up her husband's manuscript scores to use as hair curlers • "I have always written, always thrown out, always given up"—Alain Satgé • In 1969, the Argentine filmmaker Hugo Santiago directs the film *Invasion*, written by Jorge Luis Borges and Adolfo Bioy Casares; in 1978, eight of the twelve reels of the original negatives disappear from the Alex Laboratory of Buenos Aires • Francis Scott Fitzgerald writes *Notebooks* from 1932 until his death, notebooks with twenty-three chapters arranged in alphabetical order, one for each letter, though he forgot Q, X and Z; Fitzgerald dies of a heart attack on December 21, 1940, leaving Chapter VI of *The Last Tycoon* unfinished • In a documentary by Jacques Malaterre, Pascal Quignard acknowledges that he burns everything he writes • Jean-Baptiste-Camille Corot flees the revolution of 1830 in Paris without painting it • The preface promised by André Breton to Francis Picabia for his *Jesus Christ Rastaquouère* • In 1997, the city of Fribourg gives the painter Jean Miotte a sixteenth-century building to house a

foundation in his name; it burns down in September 1998 • Lost, the original copper plate of an untitled pornographic engraving by Alexis de Kermoal, from which two hundred and fifteen copies were made in 1980 • The American filmmaker, George Roy Hill, is the author of an unfinished thesis on musical themes in the work of James Joyce • Most of the unpublished texts by playwright Jean-Marie Patte have gone missing • Before starting the monologue of *How I Ate a Dog*, Yevgeni Grishkovetz wrote a version in dialogue that he destroyed: "They say manuscripts don't burn. They burn very well," he pointed out • In the Vexin, the studio of painter André François was devastated by fire; the studio of Gérard Fromanger burned down in 1964 • Only one photograph of an adult Vincent Van Gogh exists, seen from behind; not a single frontal view remains • The conception and decoration of the Aubette, a recreational facility at Kléber square in Strasbourg, was awarded to the trio of Hans Arp, Sophie Taeuber and Theo Van Doesburg; the complex was entirely

destroyed before the war • Totally deaf, the father of the writer Régis Jauffret never heard the voice of his son • Almost all of the films of Charley Bowers are lost; only sixteen short pieces of footage have survived • Irrecoverable, copies of the first two films of Fritz Lang, *The Half-Blood* and *The Master of Love* (1919) • Ninety percent of the bronzes of Greek antiquity have been lost; they were melted down • In Moscow, in the summer of 2002, the reactionary organization "Moving Together" held a public protest against the writer Vladimir Sorokin; torn up beforehand, Sorokin's books were thrown into a toilet by retirees dispatched from the suburbs; the toilet was then set on fire • In 1588, the English navy defeated the Spanish fleet, the so-called "Invincible Armada"; England became the world's greatest naval power, though not a single dramatic work of the period mentions it, not even Shakespeare's • We don't know anything about the activities of William Shakespeare between 1582 and 1592; his dramatic oeuvre includes thirty-seven works, though some were lost •

Lost, the studio of Guy Levis Mano, 6 rue Huyghens in Paris •
Cervantes used to say of himself that he should also be admired
for what he didn't write • We know neither where nor how
Baruch Spinoza learned how to grind optical lenses; at the end of
his life the philosopher wrote a *Treatise on the Rainbow*, which he
later threw into the fire, probably because of a censorship issue •
In 1889, Fernand Drujon publishes *Bibliolytie, or a Bibliographic
Essay on the Voluntary Destruction of Books* • No single French-
language work exists on the summer 1953 workers' uprising in
East Berlin • The Swiss painter Andreas Walser spends the last
eighteen months of his life in Paris painting almost two hundred
pictures; he dies in 1930 at twenty-two years of age, two thirds of
his works have disappeared • The manuscripts W.B. Yeats tore up
to obtain "good" versions of *Deirdre* and *On Baile's Strand* • *Out in
the World*, an unfinished, unpublished novel by Jane Bowles •
Chinese Series, an unfinished film by Stan Brakhage • Most of the
early works of Nicolas de Staël have been destroyed • The written

responses of Gisèle Prassinos to the letters of her editor Henri Parisot have been lost • The Society of Authors of Great Britain publishes an inquiry on behalf of nine hundred and fifty-four writers questioned about their relations with their editors; the biggest complaint: the loss or theft of manuscripts • "Is the lost secret of Atlantis dead?"—unanswered question posed by the poets of *Le Grand Jeu* • One green and blue plate from the *Four Profiles* series of Picasso's ceramics was stolen in February 2003 from the exhibition booth of the German art gallery, Pudelko, at the International Contemporary Art Fair in Madrid • Bucovina, the country of Paul Celan, formerly located between Ukraine and Romania, has disappeared • A portrait of Stendhal is believed to have been painted in Rome, in 1841, by the Swedish painter Sodermarck; we don't know what has become of it • Salvador Dalí's *Crucifixion*, 1965, hung in the mess, then in the visitor's lounge, of the penitentiary of Rikers Island, is lost in 2003 • The archaeological library of Prague is devastated by floods in the

summer of 2002 • Former residence of the French Academy in Rome, the Mancini Palace after being sacked • The *Convito* by Dante Alighieri, a collection of four books, or treatises, of scholastic philosophy, which should have numbered twelve, but from which eight books are missing; *De vulgari eloquentia (On Eloquence in the vernacular)* is not finished • Hans Christian Andersen, who worked as a singer, loses his voice; he starts writing • Goethe, lost orthographic ability; Dostoyevsky, lost syntactic ability • Aristophanes produced forty-four plays, only eleven of which have come down to us • Pieter Bruegel the Elder dies in 1569, at forty or forty-two, leaving unfinished a suite of *Four Seasons* undertaken for Hieronymus Cock • Before *The Vice*, his first published play, Luigi Pirandello produces many others, all lost or destroyed with the exception of a short one act play, *Why?* [*Perche?*], 1892 • *The New Amorous World* by Charles Fourier is unfinished • The identity of Yvonne H., the woman who inspired the character of Yvonne de Galais in *Le Grand*

Meaulnes, the sole novel of Alain-Fournier, has never been revealed • The wooden replica of the church San Carlo alle Quattro Fontane in Rome, completed in 1999 by Mario Botta at Lugano, is destroyed in an October 2003 fire after a popular festival • All of Klimt's workshops in Vienna, with the exception of the last, were razed by bulldozers in order to make room for multi-family residential buildings • Harold Pinter writes *Proust Screenplay* in 1972 for Joseph Losey; the film would never be produced • The bronze tiles of Hadrian's Villa, melted to make cannons • Most of the portraits completed by the painter Jean Fouquet (fifteenth century) were destroyed; two large religious works are preserved, the *Melun Diptych* and the *Pietà of Nouans*, the others have disappeared • The National Museum of Iraq is sacked on Friday, April 11, 2003, resulting in the loss of two to three thousand antiquities • *Poetry III*, a text by Yves di Manno, lost at Katmandu in 1974; Manno wanted this theoretical text about poetry to be published by a local press; the censors do

not read French, refuse to allow publication, and confiscate the original text which they suspect of being a political pamphlet • The indigenous art of all epochs destroyed by missionaries • Along with its two hundred thousand books, the Galesburg library disappears in a fire • A boarder for two years following a national funeral, Mirabeau is removed from the Pantheon and transferred to the cemetery of Clamart when his pornographic novels are discovered • A photograph taken by Hessling on Christmas night, 1943, of a young woman nailed alive to the village gate of Novimgorod; Hessling asks his friend Wolfgang Borchert to develop the film, look at the photograph, and destroy it • *The Beautiful Gardener* [*La Belle Jardinière*], a picture by Max Ernst, burned by the Nazis; *Forest*, another picture by Ernst left by his wife on a bus at Saint-Germain-des-Prés in 1953; the picture of Dorothea Tanning "with a blue background" that she destroyed because her husband Max did not like it • The first *Metronome*, the first *Gift* (flatiron with tacks), and the first

Painted Bread (blue) by Man Ray, all of which are exhibited in a vitrine in a Parisian gallery in 1949 and then destroyed by vandals, the word DEGENERATE written on the broken pieces before the vandals fled • *Hell*, by Henri-Georges Clouzot, 1964, was never made • Periodically, the painter Silvia Bächli does some triaging of her work, conserving the essential pieces in a binder and destroying everything else • Raymond Radiguet dies in 1923 without having had the time to correct the proofs of *Count d'Orgel's Ball*; taking on the task, his lover Jean Cocteau suppresses sixteen pages and carries out six hundred stylistic modifications • The lost death recited by Denis Diderot: "The rose of Fontenelle who said that in the memory of a rose, no gardener has ever died" • Most of the original manuscripts of Pierre Corneille were destroyed • The family china, methodically smashed, plate by plate, by the child, Johann Wolfgang Goethe, in the backyard of his paternal home; later, in the house of his hostess in Leipzig, he burns poems brought back from Frankfurt • *La Sacque amoureuse*,

a literary work by Claire C., published without the author's name • Designed by the architect Sir Joseph Paxton for London's Great Exhibition of 1851, the monumental glass structure of the Crystal Palace was destroyed by fire on November 30, 1936, shortly after a visit by Samuel Beckett • Oils on wood by the painter Pierre Lefebvre, cut into strips then nailed to strengthen the framework of more recent works • *The Other Voice* by Gozo Yoshimasu: some verses are missing between "silent lips" and "We …, the color" on page 15, beginning from line 8 • "The whole poem is lost / that before was in my neurons / quickly written, some moments / ago," Nelson Ascher • Before publishing his first book, Erri De Luca wrote a page every morning that he would tear up that evening • "We're all nameless. Incomplete," Victor Serge • The top of Constantine Brancusi's *Column* at Târgu Jiu • *Power*, a picture made of glass by Katherine White; the artist mistakenly walks on the piece in front of her, breaks the surface and passes through; "I've retained an important symbolic trace

from this episode," she says • As part of an exhibition called *Land's End*, the artist Bas Jan Ader decides to cross the Atlantic solo from Cape Cod and disappears forever • The music added by the Queen of Sweden to René Descartes' verses for the ballet *Alliance of the Rhine* • The plays written by Heiner Müller as a child were confiscated during the arrest of his father; a short story, written when he was an employee of the sub-prefecture of Warren, was lost; the final version of *The Legend of the Great Seller of Coffins* no longer exists, as well as a radio piece praising the "production"; when he learns that the minister of the Theater of the GDR wants to destroy the original manuscript of *The Emigrant*, Müller types another version overnight that he submits to the minister Bork, who publicly burns it the next morning • Aristotle's *Poetics* excludes lyric poetry from his field of investigation • Most of the written work of Petrus Borel is forever lost • "There isn't a clue that the fruit into which Adam bit was an apple & not his lady's breast," from *The Lorca Variations XI* by

Jerome Rothenberg • Recreated in Dublin, the last studio of Francis Bacon no longer exists at 7 Reece Mews, South Kensington, London • The fourth part of the *Dissertatio de amore puro* by Fenelon is missing • The "Juggler of Gravity," a character not painted on *The Large Glass*; *The Large Glass* by Marcel Duchamp, "definitely unfinished" in 1923 • *Panorama* by Cy Twombly, 1955, the only surviving dark canvas on a monumental scale • Wolfgang Heise burns his first diaries because his "image in the mirror" does not interest him • The *Sketch for a Portrait (of Pavel)*, by Lyubov Popova, is lost • The imposing sculpture *Forward* by Raymond Mason, inaugurated in 1991 in Birmingham, is completely destroyed by fire on April 17, 2003 • Louis Soutter paid for his meals with works that restaurateurs quickly tossed out; nine thousand drawings of his were lost in this way • Eleven letters from Lewis Carroll to Alice Liddell are listed among his works; all the others were destroyed by Alice's mother because of their contents • We haven't heard from Berthe

(74)

Grimault, a fifteen-year old illiterate goat keeper in Jassay that the editor René Julliard attempted to turn into a novelist • Drafted at Cambridge and submitted to the judgment of Wittgenstein, Theodore Redpath's paper about the existence (or not) of the number 7 in the infinite progression of the division of an integer by another is lost • On the death of Georg Büchner, his fiancée, Minna Jaeglé, destroys the diary of the poet, "out of piety," she says • *Medicine* and *Jurisprudence*, paintings by Gustav Klimt, are burned in 1945, in a castle in Lower Austria; in the same year, the thirteen paintings sold to Lederer are subject to an identical fate • In 2001, the Russian artist Alexander Ponomarev performs *Maya: A Lost Island* and makes the island of Sedlovaty, located in the Barents Sea, disappear within half an hour • It is no longer possible to replace the neon installations (1960–1970) of Dan Flavin because the production of "cherry red" neons have been suspended for reasons of toxicity • Bertolt Brecht removed all upper-case letters in his handwritten works; we have only a few

fragments of his drama *In One Man There Are Many*, the rest has disappeared; "wieland [herzfelde's] prague type-forms are lost (along with those for *Fear and Misery* and the *Collected Poems*)," Bertolt Brecht, *Journals*, 1934–1955 • The painter Jacques Monory destroys all his work in the early Sixties • With the increase of Noh theatrical works around the year 1400 CE, an emperor of Japan decides to preserve four hundred and fifty of them and to destroy all the others • No one is now able to say whether the English painter William Turner spoke French when he lived in Nantes • The name of the unknown, drowned woman retrieved from the Seine and whose smiling, dead face was made into a cast that inspired the sculptor Rudomine and the poets Rilke, Supervielle and Aragon • Facing routine departure of the girls he approached, filmmaker João César Monteiro reluctantly abandoned his adaptation of Sade's *Philosophy of the Boudoir*, despite asking them "nothing more than what is represented in the book" • The original sculpture, *Corner Counter-Relief*,

by Vladimir Tatlin, 1915, has been lost • At the exhibition *Pornography* by Bernard Rancillac, visitors destroyed "the most explicit parts" of the pictures • The Acanthus Column, at Delphi, which supported the Omphalos (the navel of the world), is destroyed in 373 BCE during an earthquake • In 1918, T.S. Eliot prepares a book of criticism, *The Art of Poetry*, which will not see the light of day; *The School of Donne*, the first part of a three volume series (*The Disintegration of the Intellect*), from which the second part, devoted to Elizabethan drama, as well as the third part (*The Sons of Ben*), on the development of humanism and the emergence of Hobbes, are missing; in 1923, Eliot started writing a new work, *Sweeney Agonistes*, which remains unfinished; after a year of work, he gave up writing the satirical poem *Coriolanus* • Gallery Jennifer Flay, rue Louise Weiss in Paris • The letters in "the color of blood" sent by Tristan Tzara to Max Jacob and stolen from the monastery of Saint-Benoît-sur-Loire by a scandalous visitor • Jorge Lavelli produces *Faust* in Bonn; on the evening of

the premiere, the opera house burns • André Derain and Man Ray planned to make an experimental, silent film that never came to be • Yvan Bunin dies without having finished writing his book on Anton Chekhov; Georges Bataille dies in 1962, leaving the unfinished text of *My Mother* • In 1937, in Hollywood, Salvador Dalí works successively with the Marx Brothers and Walt Disney; only a portion of a screenplay and some photos remain of the first collaboration; of the second, ten seconds of footage and a hundred drawings were preserved • Having fallen in love with an Italian countess, Brian McGuiness decides to abandon his biography of Wittgenstein, of which only the first volume, a reference work, appeared • The works and the negatives of Orlan, stored in Lyon, were lost in 1977 • Joseph Hassid, violinist • *A Book Without a Tittle*, e.e. cummings • In 1961, Jean Rouch and Edgar Morin put the finishing touches to the *Chronicle of a Summer*; a sequel to the film, envisaged some years later and featuring the same characters, would never be shot • Before

dying, Stéphane Mallarmé asks his wife and his daughter to burn his archives; thousands of documents are lost • Pierre Boulez's *Polyphonies*, a work of such great ambition that it remains in draft form • Before leaving for Moscow in 1906, Kazimir Malevich burns his production of realist and post-Romantic paintings, painted at Kursk; the original drawing for the curtain for the opera *Victory over the Sun* (1913) was lost; the scenery he created for the Red Theatre in Leningrad disappeared in a fire on November 23, 1923; in Berlin, in 1927, Malevich plans to make a film about Suprematism in collaboration with experimental filmmaker Hans Richter, but the film would never be made; in 1930, his archives are seized by the secret police or destroyed by his relatives • In the course of his life, playwright Stanislaw Witkiewicz takes a great number of photographs that will be lost, mainly during the Second World War • After 1950, Malcolm de Chazal self-publishes his books in Mauritius or Madagascar, works he will later destroy for the most part • At nineteen, Alice

Toklas writes Henry James to propose a theater adaptation of *The Awkward Age*; in response, James, himself, sends a letter, from which Alice recognizes her presumptuousness; assuming she did not have the right to keep it, she loses the letter • The furniture of the Workers Club, designed by Alexander Rodchenko for Paris's 1925 International Exhibition of Modern Decorative and Industrial Arts, is offered to the French Communist Party (PCF) at the end of the exhibition; the PCF has since lost the furniture • *Pantheon*, the second film of Jacques Grand-Jouan, with Orson Welles in the role of "Monsieur," was never completed • *Canned Dogs* [*Les Chiens de Conserve*], a scenario by Roland Dubillard for a movie that will never be made • No editor wanted to publish Friedrich Engels' pamphlet about the Spanish dancer Lola Montez, and the manuscript disappeared • Michelle Grangaud reminds you: the acceptance speech of Jean Racine cannot be found in the registry of the French Academy • Alain Gheerbrant loses two paintings by Max Ernst in a fire, including a *Forest and*

Sun, 1926 • Snapshots taken at the front between 1914 and 1918 by André Kertész, then a Hungarian soldier, have completely disappeared • Rainer Werner Fassbinder wrote a scenario for Pitigrilli's novel *Cocaine* that was never filmed • In 2004, the philosopher Jean-Louis Schefer started writing a novel that he did not intend to complete • In June and July of 1961, Cy Twombly draws the *Delian Odes* at Mykonos; they are destroyed, for the most part, by neighborhood children • At age nine, the artist Hans-Peter Feldmann burns the photographic portraits of his family in the family garden • With the exception of eighteen tanka, the work of the Japanese poetess Ono no Komachi (ninth century) has disappeared • The original relief *Automobile*, 1915, by Olga Rozanova is irrecoverable • The drawings on burnt paper by Patrick Neu were "vacuumed" by the cleaning staff during the 2003 FIAC • According to Jourdanne (1905), "the omission of *s* in the plural and the suppression of the *r* in the infinitive are the principal reproaches of the Félibrige made by its opponents" •

The manuscripts of Velimir Khlebnikov that he stuffed in his pillowcase are lost • Not a single line by Chandler survives in the script of *Strangers on a Train* by Alfred Hitchcock • *House,* 1993, the concrete cast of a London building by Rachel Whiteread is displayed for eight months at the location of the destroyed original before being destroyed in turn • In the commune of Arqua Petrarqua, near Padua, lies the body of Petrarch; the head is missing • There is no trace of the novel by Helvetia Perkins, of which Paul Bowles read the proofs in New York in 1959 • During the great fire of the Alpilles in 1999, only one house is ruined, that of Stephen Spender; two thousand books, paintings, and the poet's archives are lost • Several texts by Bohumil Hrabal, written on his Perkeo typewriter at the Nymburk brewery, have not been preserved • On August 5, 1944, Julien Green surprises Mrs. Leo Stein (sister-in-law to Gertrude) who is busy rereading, then methodically burning, some letters received from Henri Matisse • Guillaume Apollinaire claims to have lost, on a train, the

(82)

manuscript of his first novel, *The Glory of the Olive* • The first prose version of *Tristan and Iseult*, written by Luce of the Castle of Gail between 1230 and 1235, was lost • The sixteen drawings offered by Amedeo Modigliani to his lover Anna Akhmatova were "smoked" by the Red Guards, who used them as cigarette paper • The "Lost Generation" and the honor of Katharina Blum • The last seventeen measures of the *Third Concerto* of Béla Bartók are empty • Before her detention, Camille Claudel destroys all the works of her youth; pregnant by Auguste Rodin, she has an abortion, and Rodin completes his *Farewell* • In 1959, Balthus asks Giacometti to give the canvas *Coffee Pot with Three Fruits [Cafetière aux trois fruits]* to a waiter named Henri, whom they both know; forty years later, the painting is mysteriously found in the Giacometti estate; Henri still hasn't been identified

Remarks

Of all the pieces lost during the time of writing, some have since reappeared.

Several pages of this text were published in serial form every half-year in the journal *IF*, from 2001 to 2004. The author drew most of his information from biographies and autobiographies or from print newspapers. He also collected statements from writers and painters, statements published here as a mark of respect for those men and women.

H.L.

at *La Bohumila*,

Saint-Rémy-de-Provence,

July 2004

ABOUT THE AUTHOR

Henri Lefebvre, born in 1959 in Salon-de-Provence, lives and works in Paris. He founded and directs Les Cahiers de la Seine, a publishing house devoted to contemporary poetry.